ARTIST'S
WORK
BOOK

The Practical Guide to
DRAWING
PORTRAITS

ARTIST'S
WORK
BOOK

The Practical Guide to
DRAWING
PORTRAITS

BARRINGTON BARBER

ARCTURUS

ARCTURUS

This edition published in 2013 for Index Books

Copyright © 2009 Arcturus Publishing Limited/Barrington Barber

Series Editor: Ella Fern

ISBN: 978-1-84837-278-8
AD001173EN

Printed in China

CONTENTS

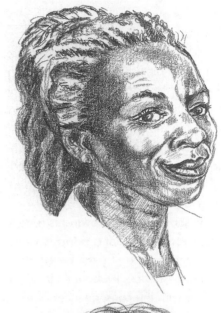

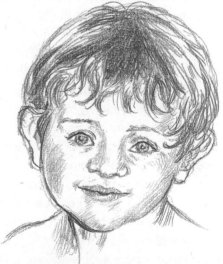

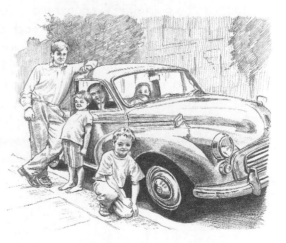

INTRODUCTION

What is a portrait? It is said that Picasso produced a Cubist portrait of a friend and when this was shown to Matisse he could not identify the person. Picasso then stuck a moustache on to the picture and Matisse could immediately see the likeness. This story exemplifies a fundamental aspect of portraiture: no matter how far from an exact likeness a drawing may be, it must contain some recognizable form of the person. In order to capture this you will need to spend a lot of time in direct observation, noting the particular image of a human being that your subject represents.

How much you should flatter or be brutally honest with your subject when drawing is a perennial question. If they, like Cromwell, want a portrait 'warts and all' then the more objective you can be the better. However, very few people are honest enough about their own appearance to be able to live with the consequences of this approach, and so most portrait artists try to give the best possible view of the sitter. This may mean altering the light effects, changing the position of the head slightly, getting the sitter to relax, and employing other small ways of helping to ease tension out of the face and bring some agreeable element into prominence. Fortunately, most people have some good feature that can be the focal point of a portrait, allowing the artist to slightly reduce the importance of a tense mouth, a weak chin or rather protruding ears or nose. The ravages of time have also to be taken into account, although lines, creases or sagging flesh can be slightly softened to give a more acceptable version which is still recognizable.

Throughout this book you will find a range of approaches and valuable lessons to absorb and learn from. There isn't a portrait in the pages that follow that can't teach us something about the way to approach depicting the features of your friends, family, acquaintances and even complete strangers. What I hope you will also come to realize is that although the measurable differences between all the faces portrayed are really very minute, the appearances are immensely varied. The human face has an extraordinary ability to show a whole range of expressions and emotions. It is this facility which artists have striven for generations to explore in myriad ways.

What comes out of this exploration does, of course, depend on the skill of the artist. The only way to reach the level of skill required to produce good portraits is to practise drawing. The more you practise, the better you will get. If you can't regularly practise drawing faces, any type of drawing is a valid way to increase your skills. Change the situation, the lighting and the surroundings and you will have a different portrait. This is why so many artists find portraiture endlessly fascinating. There really is no limit to the possibilities for expression it offers.

Barrington Barber

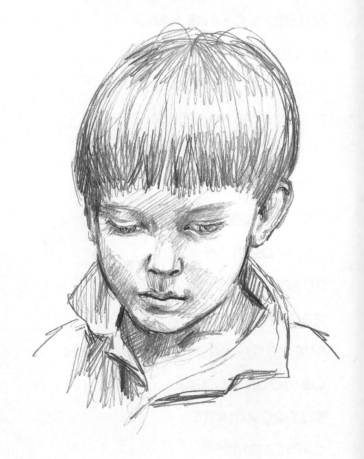

Materials

Any medium is valid for drawing portraits. That said, some media are more valid than others in particular circumstances, and in the main their suitability depends on what you are trying to achieve. You don't need to buy all the items listed below, and it is probably wise to experiment gradually, as you gain in confidence. Start with the range of pencils suggested, and when you feel you would like to try something different, then do so. Be aware that each material has its own identity, and you have to become acquainted with its qualities before you can get the best out of it or, indeed, discover whether it is the right material for your purposes. So, don't be too ambitious to begin with, and when you do decide to experiment, persevere.

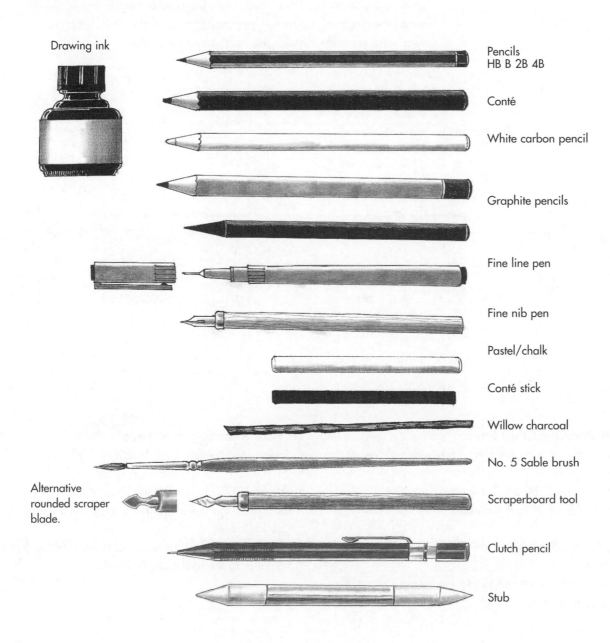

Drawing ink

Pencils
HB B 2B 4B

Conté

White carbon pencil

Graphite pencils

Fine line pen

Fine nib pen

Pastel/chalk

Conté stick

Willow charcoal

No. 5 Sable brush

Alternative rounded scraper blade.

Scraperboard tool

Clutch pencil

Stub

PROPORTIONS OF THE HEAD

For beginners especially it can be very helpful to use a grid as a guide on which to map out the head, to ensure that the proportions are correct. Those shown here are broadly true of all adult humans from any part of the world, and so can be applied to anyone you care to use as a model. The head must be straight and upright, either full face or fully in profile. If the head is at an angle the proportions will distort.

For these two full-face examples, a proportion of five units across and seven units down has been used. Note the central line drawn vertically down the length of the face. This passes at equidistance between the eyes, and centrally through the nose, mouth and chin.

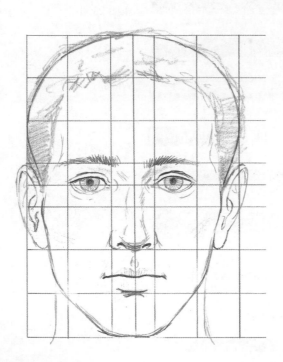
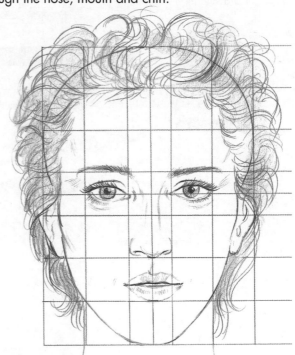

Horizontal Reading: Full Face
- The width of the eye is one-fifth of the width of the whole head and is equal to 1 unit.
- The space between the eyes is 1 unit.
- The edge of the head to the outside corner of the eye is 1 unit.
- The outside corner of the eye to the inside corner of the eye is 1 unit.
- The inside corner of the left eye to the inside corner of the right eye is 1 unit.

Vertical Reading: Full Face
- Eyes: halfway down the length of the head.
- Hairline: 1 unit from the top of the head.
- Nose: 1 1/2 units from the level of the eyes downwards.
- Bottom of the lower lip: 1 unit up from the edge of the jawbone.
- Ears: the length of the nose, plus the distance from the eye-line to the eyebrows is 2 units.

For easy comparison, these two profile examples have been drawn to exactly the same size as those on the preceding page. The head in profile is 7 units wide and 7 units long, including the nose.

Don't forget that the human head is different in each individual. These grids will help you to look at the distances between features, but it is your observational skills that will be needed to create a likeness.

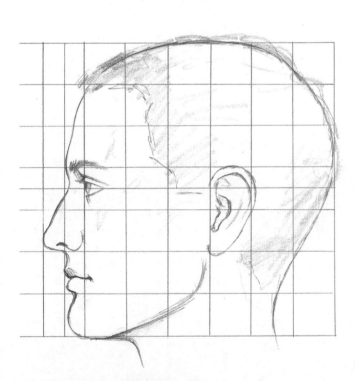

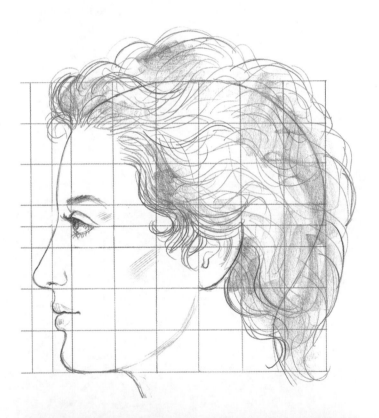

Horizontal Reading: Profile

- The front edge of the eye is 1 unit back from the point of the nose.
- The ear is 1 unit in width. Its front edge is 4 units from the point of the nose and 3 units from the back edge of the head.
- The nose projects half a unit from the front of the main skull shape.

HANDY HINT

It is important to remember that, while the female head is generally smaller than the male, the proportions are exactly the same. See page 12 for information on the head proportions of children, which at certain ages are significantly different from those of adults.

MEASURING THE HEAD

The surest way of increasing your understanding of the head, and becoming adept at portraying its features accurately, is to practise drawing it life size, from life. It is very difficult to draw the head in miniature without first having gained adequate experience of drawing it at exactly the size it is in reality, but this is what beginner artists tend to do, in the mistaken belief that somehow it will be easier.

Getting to know the head involves mapping it out, and this means measuring the distances between clearly defined points. For the next exercise you will need a live model, a measuring device, such as a ruler or callipers, a pencil and a large sheet of paper.

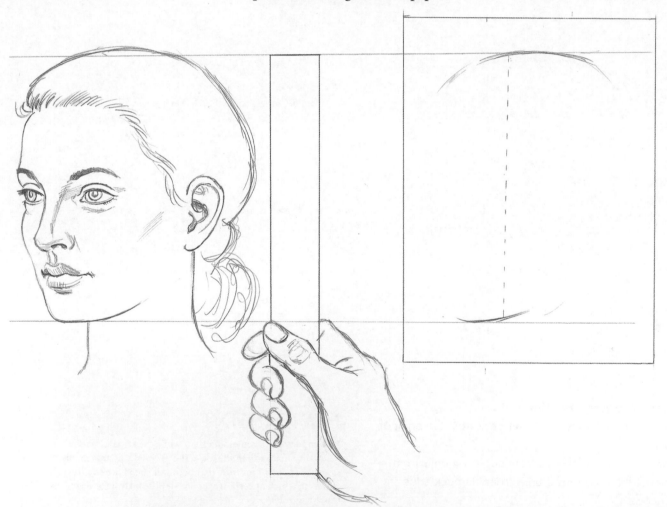

Measure the length of the head from the highest point to the tip of the chin. Mark your measurement on the paper. Measure the width of the head at the widest point; this is usually across the area just above the ears, certainly if viewed full on from the front. Mark this measurement on the paper. The whole head should fit inside the vertical and horizontal measurements you have transferred to your drawing paper.

Measure the eye level. This should be about halfway down the full length of the vertical, unless the head is tilted. Decide the angle you are going to look at the head. Assuming it is a three-quarter view, the next measurement is critical: it is the distance from the centre between the eyes to the front edge of the ear.

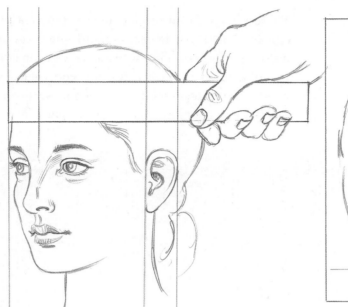

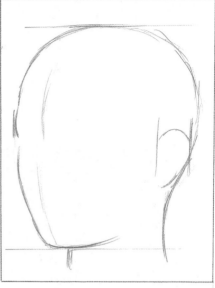

Measure the distance from the outside edge of the nostril to the front edge of the ear. Mark it and then place the shape of the ear and the position of both eyes. Check the actual length of the nose from the inside corner of the eye down to the base of the nostril. Next measure the line of the centre of the mouth's opening; you can calculate this either from the base of the nose or from the point of the chin. Mark it in. Now measure from the corner of the mouth facing you to a line projecting down the jawbone under the ear. Mark it.

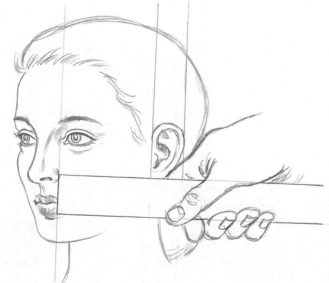

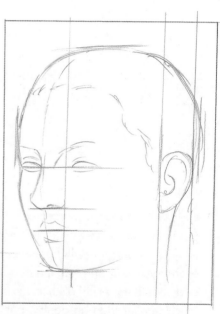

HANDY HINT

It is important to draw the shape of the head and the position of the features from different angles, as the appearance can differ radically.

THE PROPORTIONS OF CHILDREN

There are significant proportional differences between children and adults which the artist has to bear in mind when undertaking a portrait. One of the most obvious is seen in the head, which in an adult is about twice as large as that of a two-year-old. The features, too, change with growth. In adults the eyes are closer together and are set halfway down the head. Nose, cheekbones and jaw become more clearly defined and more angular as we mature.

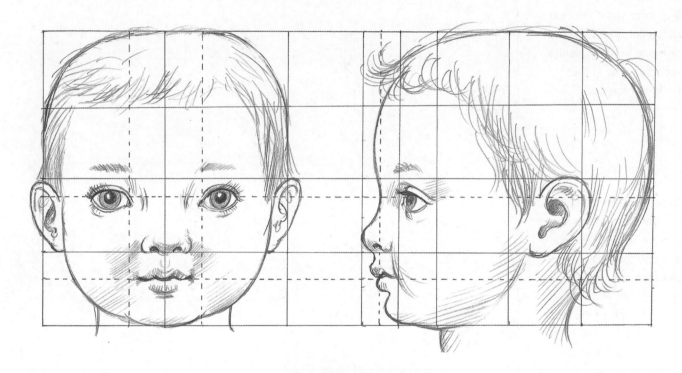

The Head: Major Differences

- In relation to its body, a child's head is much larger; this will be evident even if you can only see the head and shoulders. A child's head is much smaller than an adult's, but the proportion of head to body is such that the head appears larger.
- The cranium or upper part of the child's skull is much larger in proportion to the rest of the face. This gradually alters as the child grows and reaches adult proportions.

- The child's eyes appear much larger in the head than an adult's, whereas the mouth and nose often appear smaller. The eyes also appear to be wider apart. The nose is usually short with nostrils facing outward so that it appears upturned. This is because the nasal bones are not developed.
- The jawbones and teeth are much smaller in proportion to the rest of the head, again because they are still not fully developed. The rule with the adult – that places the eyes

halfway down the head – does not work with a child, where the eyes appear much lower down.
- With very young children, the forehead is high and wide, the ears and eyes very large, the nose small and upturned, the cheeks full and round and the mouth and jaw very small.
- The hair is finer, even if luxuriant, and so tends to show the head shape much more clearly.

An exercise in steps

Capturing the likeness of a subject can be problematical, as can choosing the position from which to draw the face. This position gives some idea of the kind of person you are drawing. Aggressive people look up or straight ahead, chin raised. Gentler people tend to look down, as with this young model. Let's take a step-by-step look at drawing him.

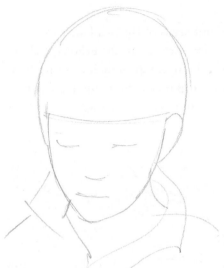

Step 1

Before you start, look at the shape of the head as a whole. Study it; it is essential that you get this right.

Now draw an outline, marking the area of hair and the position of the eyes, nose and mouth.

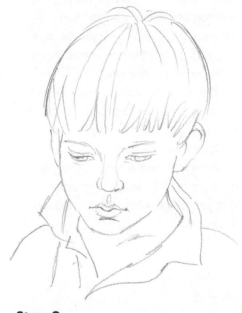

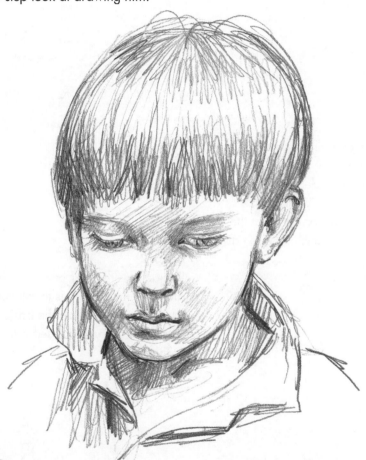

Step 2

Build up the shapes of the ears, eyes, nose, mouth and a few more details such as the hair and neck.

Step 3

In the final drawing, effort has gone into the areas of tone or shadow, the quality of hair and shirt and the tonal variations of the shading around the eyes, nose and mouth in order to define the features. You'll notice that the lines of tone go in various directions. There is no single, 'right' way of doing this. In your own drawings you can try out single direction toning, multi-direction toning, shading around and in line with the contours and, where appropriate, smudging or softening the shading until it becomes a soft grey tone instead of lines. What you do – and what you think works – is simply a matter of what effect you wish to achieve. Softer, smoother tones give a photographic effect, while more vigorous lines inject liveliness.

DRAWING THE HEAD: BASIC METHOD

As on the previous pages, the basic shapes and areas of the head have to be taken into account when you start to draw any portrait. In the exercise below I cover five basic steps. These will give you a strong shape which you can then work over to get the subtle individual shapes and marks that will make your drawing a realistic representation of the person you are drawing.

Step 1

Ascertain the overall shape of the head or skull and the way it sits on the neck. It may be very rounded, long and thin or square and solid. Defining the shape clearly and accurately at the outset will make everything else easier later on.

Step 2

Decide how the hair covers the head and how much there is in relation to the whole head. Draw the basic shape and don't concern yourself with details at this stage.

Step 3

Now ascertain the basic shape and position of the features, starting with the eyes. Make sure you get the level, size and general shape correct, including the eyebrows.

The nose is next, its shape (whether upturned, straight, aquiline, broad or narrow), its tilt and the amount it projects from the face.

Now look at the mouth, gauging its width and thickness, and ensuring that you place it correctly in relation to the chin.

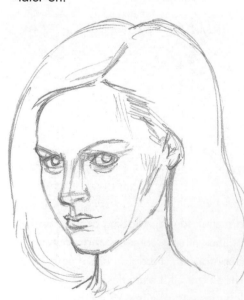

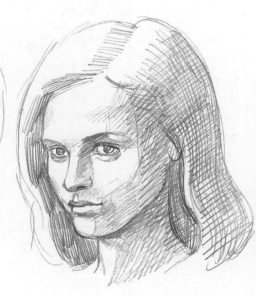

Step 4

The form of the face is shown by the tonal qualities of the shadows on the head. Just outline the form and concentrate on capturing the general area correctly.

Step 5

Work in the tonal values over the whole head, noting which areas are darker and which are not so dark, emphasizing the former and softening the latter.

DRAWING THE HEAD: ADVANCED METHOD

An alternative method is to work from the centre of the features and move outwards toward the edges. Start by drawing a vertical line down the middle of your paper and then make a mark at the top and bottom of it. Now follow the steps shown here. Look carefully at your model throughout the exercise.

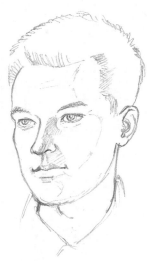

Step 1
Mark a horizontal line for the position of the eyes, halfway between your top and bottom marks. Roughly draw in the relative position and shapes of the eyes.

Step 2
Draw in the shapes of the eyes and eyebrows. Notice how the eye nearest to you is seen more full on than the eye further away. Try to define the point where the further eyebrow meets the edge of the head as seen from your position.

Step 3
Trace out the shape of the shadows running down the side of the head facing you. Don't make the lines too heavy.

Step 4
Begin by darkening the areas that stand out most clearly. Carefully model the tone around the form – especially the side of the nose and the top lip, for example – so that where there is a strong contrast you increase the darkness of the tone and where there is less contrast you soften it, even rubbing it out if necessary. Build up the tonal values with care, ensuring that in the areas where there is a gradual shift from dark to light you reflect this in the way you apply tone.

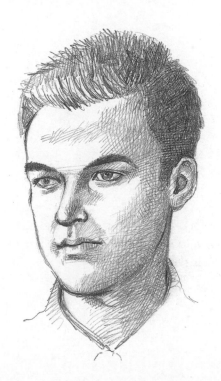

HANDY HINT
Always try to reproduce exactly what you see in front of you, and not what you don't see. Trust your eyes. They are very accurate.

DIFFERENT AGES

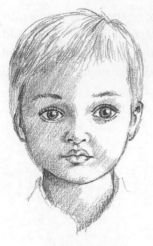

In these examples of children's heads, the main thing to notice is the simplicity of their faces. There are hardly any lines at all, and the firm flesh pushes outwards to create rounded shapes. The features are also much less prominent in the face, in all cases only projecting a little way out from the main shape of the head. It has always been a difficult thing to draw children's faces well, because there is not all that much to draw.

Also notice that the nose and mouth seem much closer to each other than in the adults on the facing page. The profile view shows how little the nose and chin project from the front of the face, and the area of the hair always seems to be quite large in contrast to the rest of the head.

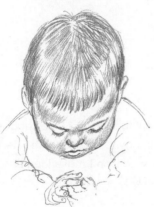

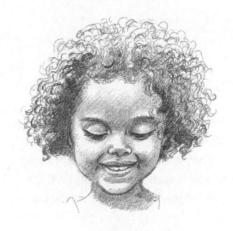

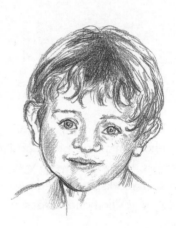

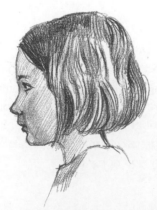

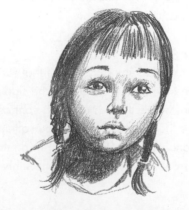

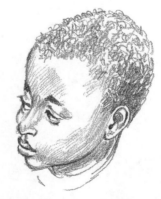

Although all these children are different in looks, they all reduce to very simple forms of eyes, nose and mouth, with round faces and soft, luxuriant hair. Very young heads like these hold various difficulties for the artist. First and foremost you will need to decide where to make the strongest of your marks, because if you get it wrong it will reduce the effect of youth.

A lot of your marks will have to be quite delicate, to show the softness of their skin and features.

The marks made when drawing adults are complex but much more definite. Go at once for the most characteristic features that the head in front of you exhibits. Recognition is mainly in the relationship of the eyes, nose and mouth, and then the general shape of the head. Don't worry if at first it turns out to be more like a caricature, because it is easier to soften and reduce the forms than it is to strengthen them. Older faces have their character more clearly etched than younger faces. An alternative method is to work from the centre of the features and move outwards toward the edges. Start by drawing a vertical line down the middle of your paper and then make a mark at the top and bottom of it. Now follow the steps shown here. Look carefully at your model throughout the exercise.

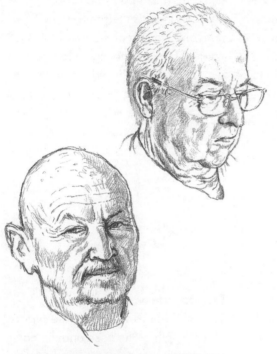

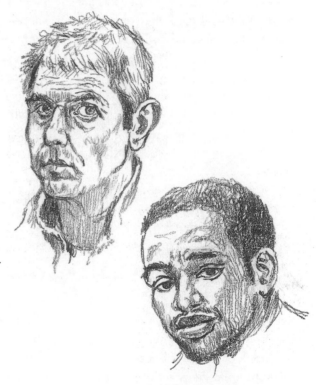

The two younger men show strong definite marks on the surface of their faces, while the older men's faces look less powerful because of the softer flesh and the etched lines. Notice how the hair becomes thinner and less shiny with age – sometimes disappearing altogether!

HANDY HINT

Take care when drawing darker skin colours than white. Your range of tonal values needs to be wider and more subtle in order not to risk losing a sense of form and structure.

With the two women, the older woman's face looks much more fragile and less dramatic. The younger woman has stronger, well-defined features and the signs of ageing on her face are much less obvious.

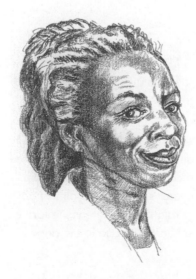

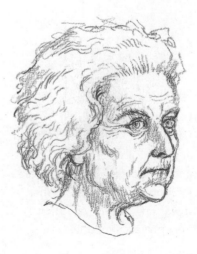

THE FEATURES CLOSE UP

EYES
Seen in profile the eye is a simple shape to draw.

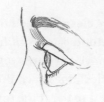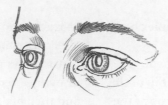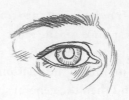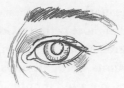

Profile view
The eyelids should project beyond the curve of the eyeball: if they didn't project, the eye could not close.

Three-quarter view
Note a marked difference in the shapes. The further eye is closer to the profile view in that the eyelid projects past the eyeball on the outside corner. On the nearer eye, because the inside corner is visible, the shape appears to be more complete. The far eyebrow appears shorter than the near one.

Frontal view
From this angle the eyes are more or less a mirror image. The space between them is the same as the horizontal length of the eye. Note that normally about one-eighth to one-quarter of the iris is hidden under the upper eyelid, and the bottom edge just touches the lower lid.

NOSE
The nose at different angles presents marked differences in shape. In very young people the nostrils are the only areas that stand out.

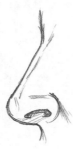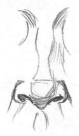

Profile view
The main observation here concerns the shape of the nostril and its relationship to the point of the nose.

Three-quarter view
The outline shape is still evident but notice how its relationship to the nostril has changed.

Frontal view
The only shapes visible are the surface of the length of the nose and the point. The nostrils are the most clearly defined areas, so note their relationship.

MOUTH
Profile view

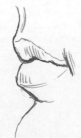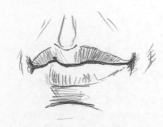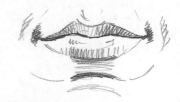

The line of the mouth (where the lips part) is at its shortest in this view. Note whether the upper lip projects further than the lower lip, or vice versa, or whether they project similarly.

Three-quarter view
The angle accounts for the difference in the curves of top and bottom lip. The nearer side appears almost as it does straight on, whereas the farther side is shortened due to the angle.

Frontal view
This view is the one we are most familiar with. The line of the mouth is very important to draw accurately – you need to capture its shape precisely or the lips will not look right.

The angle of the eyes as they appear in relation to each other –

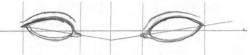

Do they look straight across from corner to corner?

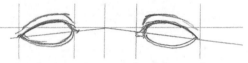

Do the inner corners look lower than the outer corners?

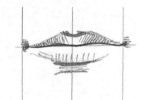

Do the outer corners look lower than the inner corners?

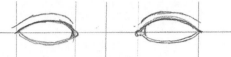

HANDY HINT

Remember to look at the hairline since getting this right can make a big difference to your likeness – is it straight or uneven?

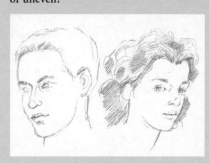

The measurements you have taken in the previous exercises will provide accurate proportions for you to work to when drawing the features. When you have sketched out roughly where every feature begins and ends, look carefully at the shapes of each of them and then draw them in.

The eyes are often what makes a person recognizable to us; the mouth and nose are next. The rest depends on the characteristics of your subject. The illustrations on this page show the main points and relationships to consider when drawing the features.

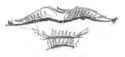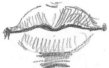

The curve of the mouth – Is it dead straight? … up? … down?

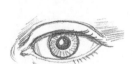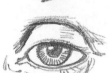

LIPS
Are they thin?
Are they generous?

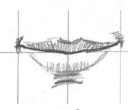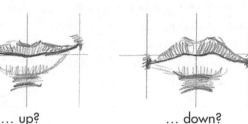

The eyelids
Are they narrow?
… or broad?

The eyebrows
Are they curved?
… or straight?

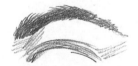

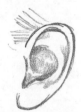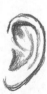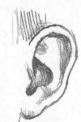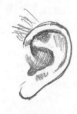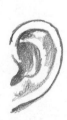

EARS
These come in a variety of permutations; here are a few for you to consider.

BONES OF THE HEAD

We need to remind ourselves frequently when drawing portraits that what we see is due entirely to structures that are for the most part hidden from view. This is particularly truc of the bones that underlie the skin and muscles. An understanding of the landscape of the skull is necessary if we are to draw good portraits. Look at the features identified on the drawings below and see if you can find them on your own head by touch.

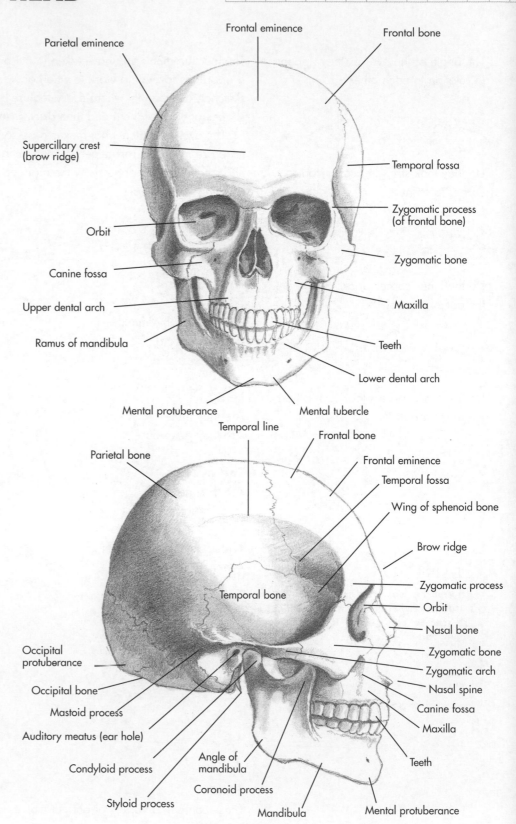

Parietal eminence

Frontal eminence

Frontal bone

Supercillary crest (brow ridge)

Temporal fossa

Zygomatic process (of frontal bone)

Orbit

Zygomatic bone

Canine fossa

Maxilla

Upper dental arch

Ramus of mandibula

Teeth

Lower dental arch

Mental protuberance

Mental tubercle

Temporal line

Frontal bone

Parietal bone

Frontal eminence

Temporal fossa

Wing of sphenoid bone

Brow ridge

Zygomatic process

Temporal bone

Orbit

Nasal bone

Zygomatic bone

Zygomatic arch

Occipital protuberance

Nasal spine

Canine fossa

Occipital bone

Maxilla

Mastoid process

Teeth

Auditory meatus (ear hole)

Angle of mandibula

Condyloid process

Coronoid process

Mental protuberance

Styloid process

Mandibula

MUSCLES OF THE HEAD

Movement and expression are two principal elements of portraiture and both are governed by the muscles. It is important to know where the muscles are and how they behave if we are to produce portraits of character and individuality. Study the following illustrations and the accompanying annotations.

Muscle/Function

Corrugator: Pulls eyebrows together

Orbicularis oculi: Closes eyes

Quadratus labii superioris: Raises upper lip

Orbicularis oris: Closes mouth and purses lips

Mentalis: Moves skin of chin

Masseter: Upward traction of lower jaw; energetic closing of mouth

Occipital part of epicranius: Backward traction of epicranial aponeurosis and skin

Frontal part of epicranius: Moves skin on top of head

Compressor nasi: Narrows nostrils; downward traction of nose

Levator angulis oris: Raises angle of mouth

Zygomaticus major: Energetic upward traction of angle of mouth

Depressor anguli oris: Downward traction of angle of mouth

Depressor labii inferioris: Energetic downward pull of lower lip

Trapezius risorius: Lateral pulling of angle of mouth

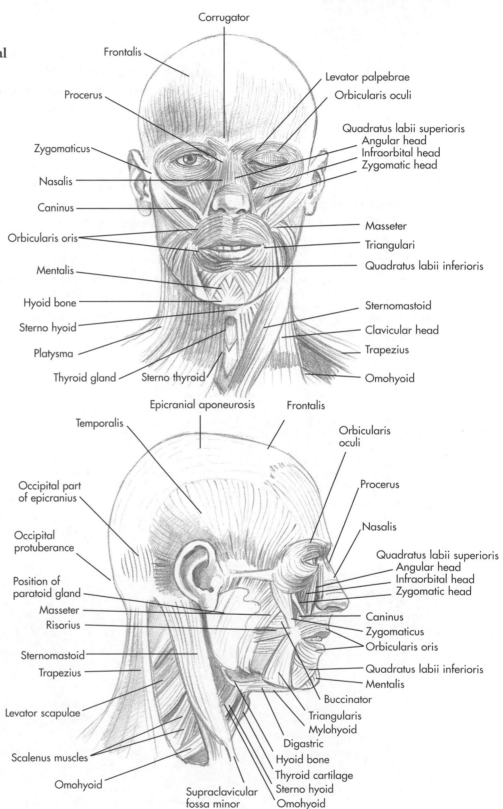

21

SETTING UP A PORTRAIT

When you are confident of your ability to draw the features accurately, you are ready to try your hand at a full-scale portrait. Someone may commission you to draw a portrait, but it is more likely you will have to initiate the event yourself, especially in the beginning.

You will need to agree on a number of sittings with your model, and how long each of these should last; two or three sittings of between 30 minutes and one hour should be sufficient. It is advisable not to let your subject get too bored with sitting, because dullness may creep into their expression and into your portrait.

Once the schedule has been decided, it is time to start work. First, make several drawings of your subject's face and head, plus the rest of the body if that is required, from several different angles. Aim to capture the shape and form clearly and unambiguously. In addition, take photographs: front and three-quarter views and possibly also a profile view.

All this information is to help you decide which is the best view, and how much of their figure you want to show.

The preliminary sketching will also help you to get the feel of how their features appear, and shape your ideas of what you want to bring out in the finished work. Changing light conditions and changing expressions will give subtle variations to each feature. You have to decide exactly which of these variations to include in the drawing.

HANDY HINT

Decide on the pose. If you choose to put your model in a chair, or incorporate some other prop, include the chair or prop in your sketches. See pages 34–9 for more on designing a composition and posing.

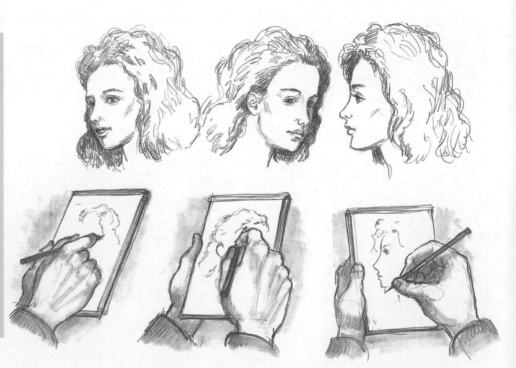

Draw the face from left and right and also in profile.

Rule of Thumb

When drawing at sight size – the size a figure or object looks from where you are standing – the proportions can be gauged by using the rule of thumb method. Take the measurement by holding your arm outstretched with your pencil upright in line with the drawing board (see illustration below). Once the measurement has been taken, you can then transfer it to your drawing paper.

You must ensure that you measure everything in your drawing in the same way, keeping the same distance from your model and your pencil extended at arm's length. If you do this, the method will give you a fairly accurate range of proportions. Deviate from this, however, and you will find your proportions looking decidedly out of kilter.

The rule of thumb method can also be used when drawing larger than sight size, by extrapolating from the proportions. However, only experienced artists should attempt this. For those in the early stages of learning to draw it is always helpful and instructive to draw much larger than rule of thumb allows, at larger than life size preferably, so that mistakes can be seen clearly and the necessary corrections made.

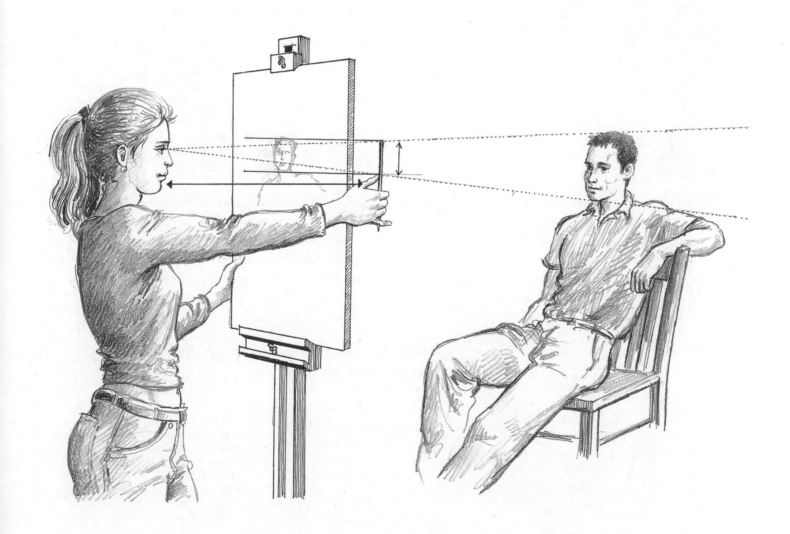

LIGHTING YOUR SUBJECT

Any portrait will be affected by the sort of lighting used, whether natural or artificial. The artist Ingres described the classical mode of lighting as 'illuminating the model from an almost frontal direction, slightly above and slightly to the side of the model's head'. This approach has great merit, especially for beginners in portraiture, because it gives a clear view of the face, but also allows you to see the modelling along the side of the head and the nose, so that the features show up clearly.

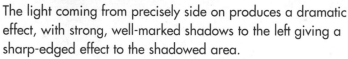

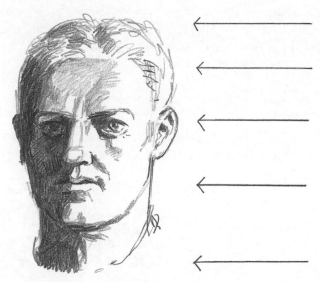

The light coming from precisely side on produces a dramatic effect, with strong, well-marked shadows to the left giving a sharp-edged effect to the shadowed area.

The three-dimensional aspect of the girl's head is made very obvious by lighting coming from directly above, although the whole effect is softer than in the previous example. The shadows define the eyebrows and cheekbones and gently soften the chin and lower areas of the head.

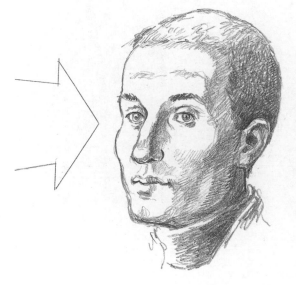

Lighting the face from the front and to one side (as advocated by Ingres) gives a very even set of shadows – in this example on the right side – and clearly shows the bone structure.

HANDY HINT

As this series of images shows, directional lighting can make an immense difference to a face. The same principles apply equally to figures and objects. Experiment for yourself, using a small lamp or candles. Place objects or a subject at various angles and distances from a light source and note the difference this makes.

With artificial lighting, you can control the direction and amount of light and you are not dependent on the vagaries of the weather. To achieve satisfactory results, several anglepoise lamps and large white sheets of paper to reflect light will do.

Lighting from behind the subject has to be handled very carefully; while it can produce very subtle shadows, there is a danger of ending up with a silhouette if the light is too strong. Usually some sort of reflection from another direction creates more interesting definitions of the forms.

The only directional lighting that is not very useful is lighting from beneath the face, because light from below makes the face unrecognizable.

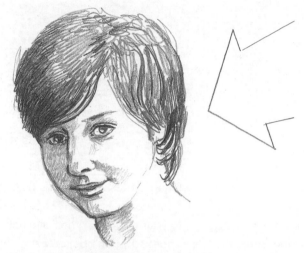

Lit frontally and from above this example also owes a debt to Ingres. The slight tilt of the head allows the shadows to spread softly across the far side of the face.

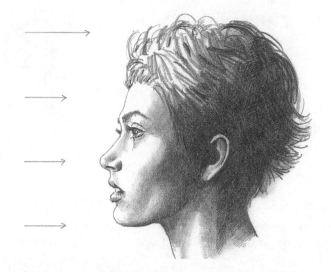

Lighting the model from directly in front shows the features strongly, subsuming the areas of the hair and the back of the head in deep shadow.

Lighting from behind is not usual in portraiture although it has been done quite effectively. The trick is not to over-do it.

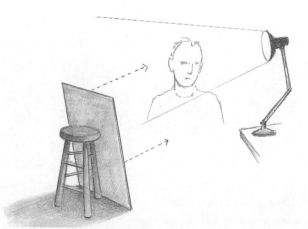

Reflected light can be used to flatten out too many shadows cast over the face. If you want to try this, place a large white sheet of card or similar opposite your light source.

There are various ways of producing an effective picture by varying the technique you use. Here are a few variations in the treatment of the head of a young man to show you some of the stylistic possibilities.

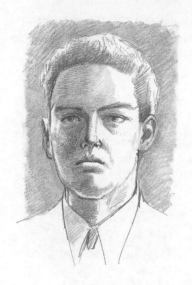

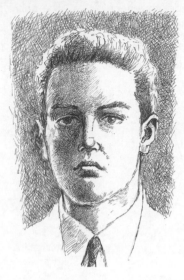

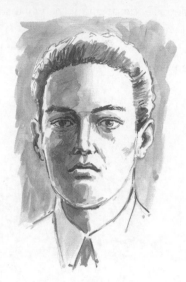

The tones have been worked over with a stub, smudging the pencil to produce a softer, more gradual tonal effect on the areas of shadow.

The method used here, in ink, is time consuming. The tonal areas have been carefully built up with different kinds of cross-hatching and random strokes, giving a solid feel to the head.

Using a brush and ink or watercolour in one colour will give a painterly feel to your portrait. When attempting this approach, don't be too exact with your brush-strokes.

This last method is all about using technique to capture form, not likeness. Once you have got the features and tonal areas down, begin the technical exercise of making the outlines very smooth and continuous. Then, with a stub, work on the tonal areas until they graduate very smoothly across the surface and are as perfect in variation and as carefully outlined as possible.

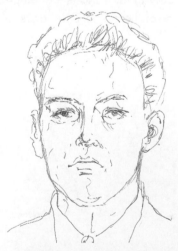

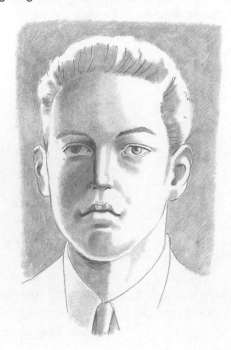

There has been no attempt to build up tone in this example in ink. Open and loosely drawn, it is a very rapid method requiring confidence and facility with the pen.

EXERCISES IN TECHNIQUE

Pencil and Graphite

A pencil is the easiest and most obvious implement with which to start an exploration of technique. Try the following series of simple warming up exercises, which can be practised every day that you put aside time to draw. This is very useful for improving your technique.

Using a pencil, draw out a long line of squares measuring about 2.5cm (1in). Shade each one, starting with a totally black square. Allow the next square of shading to be slightly lighter, and so on, gradually shading each square as uniformly as possible with a lighter and lighter touch, until you arrive at white paper.

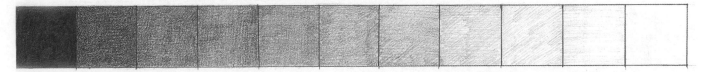

Building up tones by crosshatching

1. Vertical strokes first, close together

2. Oblique strokes from top right to bottom left over the vertical strokes

3. Horizontal strokes over the strokes shown in 1 and 2.

4. Then make oblique strokes from top left to bottom right over the strokes shown in 1–3.

HANDY HINT

Smooth and finely graduated tones can be achieved by working over your marks with a stub.

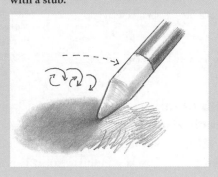

Try using a graphite stick for the next two exercises; they can also be done with a well-sharpened soft pencil.

Lay the side edge of the point of the graphite or pencil on to the paper and make smooth, smudged marks.

Using the point in random directions also works well.

EXERCISES IN TECHNIQUE

Pen and Ink

There is a whole range of exercises for pen work but of course this implement has to be used rather more lightly and carefully than the pencil so that its point doesn't catch in the paper.

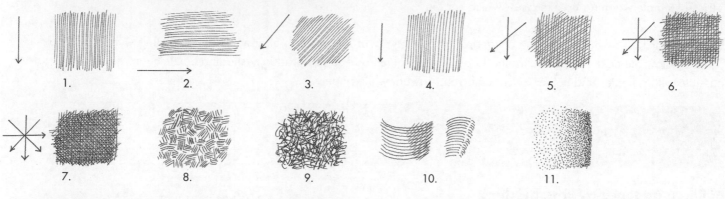

1. Vertical lines close together in one direction.
2. Horizontal lines close together in one direction.
3. Oblique lines close together in one direction.

 Repeat as above but this time building up the strokes:
4. Draw vertical lines.
5. Draw oblique lines on top of the verticals.

6. Draw horizontal lines on top of the oblique and vertical lines.
7. Draw oblique lines at 90 degrees to the last oblique lines on top of the three previous exercises to build up the tone.
8. Make patches of short strokes in different directions, each time packing them closer together.

9. Draw small overlapping lines in all directions.
10. Draw lines that follow the contours of a shape, placing them close together. For an additional variation, draw oblique lines across these contour lines.
11. Build up myriad dots to describe tonal areas.

Shading with Chalk

This next series of exercises is similar to the one you have just done but requires extra care not to smudge your marks as you put them down. The key in this respect is not to use a smooth paper. Choose one with a texture that will provide a surface to which the chalk can adhere.

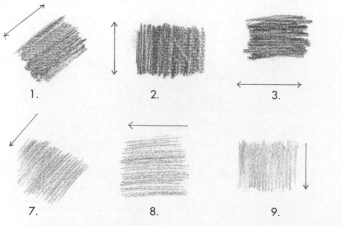

1. Shading obliquely in two directions.
2. Shading vertically in two directions.
3. Shading horizontally in two directions.

4. Shading in various directions, heavily.
5. Shading in various directions, more lightly.
6. Shading in various directions, very lightly.

7. Shading in one direction obliquely.
8. Shading in one direction horizontally.
9. Shading in one direction vertically.

Brush and Wash

The best way to start with brush and wash is to try these simple exercises. Your brush should be fairly full of water and colour, so mix a generous amount on a palette or saucer first, and use paper that won't buckle.

With a brush full of ink or watercolour diluted in water, lay a straightforward wash as evenly as possible on watercolour paper.

Repeat but this time brushing the wash in all directions.

Load a lot of colour onto your brush and then gradually add water so that the tone gets weaker as you work. Keep working with the brush until it finally dries and you wipe out the last bit of colour.

Practise drawing soft lines with a brush and wash.

Scraperboard

Take a fine pointed and a curved edge scraper and try your hand at scraperboard. The curved edge tool produces broader, thicker lines than the pointed tool, as can be seen from the examples shown below.

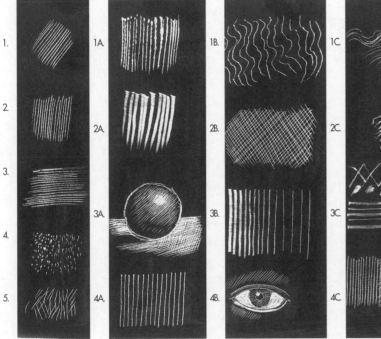

1. Oblique fine line
2. Vertical fine line
3. Horizontal fine line
4. Short pecks
5. Short pecks and strokes
1A. Thicker vertical lines
2A. Even thicker vertical lines
3A. Draw a ball, then scrape away to reveal lighter side
4A. Thin, measured vertical strokes
1B. Scraped wavy lines
2B. Crosshatching with fine lines
3B. Gradually reducing from thick to fine lines
4B. Draw eye shape and then scrape out light areas
1C. Lightly scraped wavy lines
2C. Thickly scraped wavy lines
3C. Criss-cross pattern
4C. Multiple cross-hatching increasing in complexity from left to right

STYLES

On the following pages are a series of examples of portraits using the different techniques we have looked at. Some are more finished than others, but they all have a unique style and capture something of the character of the sitter.

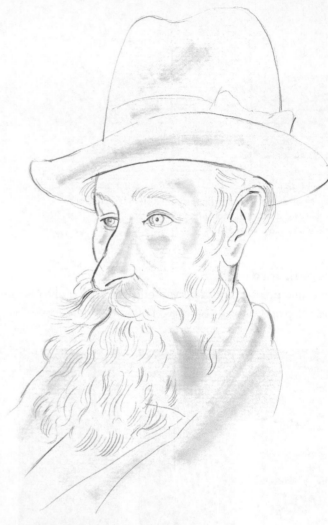

The details of the face are simplified and most of the tonal values dispensed with in this copy of a drawing of Aristide Maillol by fellow sculptor Eric Gill. The different emphasis in the outlines helps to give an effect of dimension, but it is more like the dimension of a bas-relief sculpture.

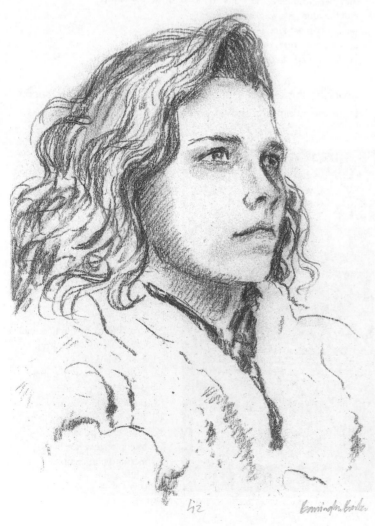

This black chalk drawing on a tinted paper took about twenty minutes. The style is fairly simple and the technique quite easy. The face has been drawn in without much modelling and with the emphasis on placing the features correctly. Interest has been created by the texture of the chalk line and the model's attractive longish hair.

The most time-consuming aspect of this pen and ink drawing (fountain pen with a fine point on fairly thin paper) was tracing out the profile. The drawing had to be done quickly because the model was only available for a few minutes, being part of a class of art students sitting for one another. The outline was the main point of emphasis, with a bit of tone, especially on the hair. It is important with quick drawings to concentrate on one aspect and not try to be too clever.

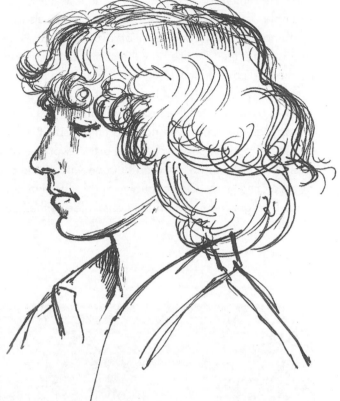

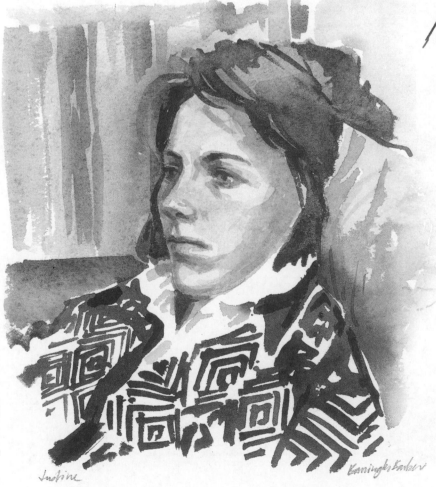

Plenty of water has been used to keep the tones on the face and the background soft in this example of watercolour on watercolour paper. The strength of colour on the jacket and hair is greater than elsewhere in the picture. The eyes, nose and mouth need touches of strong tone, especially the line of the mouth and the upper eyelashes, eyebrows and pupils of the eyes. This type of drawing can be built up quite satisfactorily, with the lighter tones put in first all over and then strengthened with the darks.

The most dimension is achieved for the least effort in this example. The reason is the use of three materials in combination: brown and terracotta conté pencil, white chalk and toned paper. Notice how the strong emphasis provided by the darker of the conté pencils is kept to a minimum, sufficient to describe what is there but no more. Similarly the chalk is used only for the strongest highlights. The mid-tone is applied very softly, with no area emphasized over-much. The toned paper does much of the artist's work, enabling rapid production of a drawing but one with all the qualities of a detailed study. Often you will find it effective to include some background to set off the lighter side of the head.

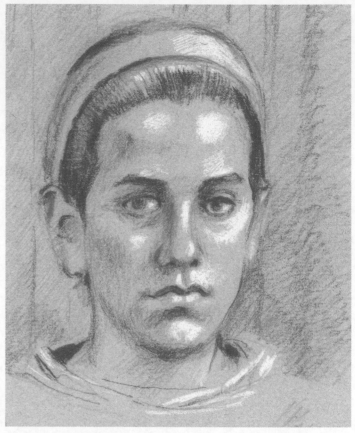

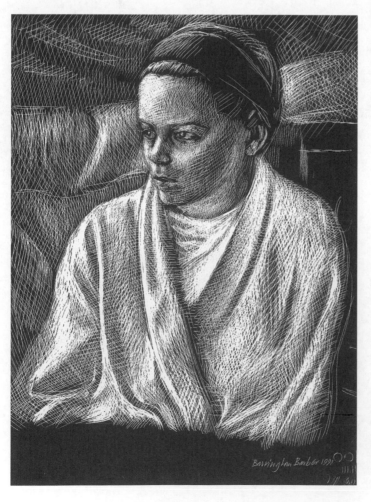

With scraperboard technique the artist has to draw back-to-front, revealing all the light areas and leaving the dark ones. This subject was ideal, her white bath-robe ensuring there were plenty of light areas, although it was difficult to judge how much to work the face. The hair and hairband were made up of dark tones, and so required only the addition of highlights.

HANDY HINT

Similar effects to scraperboard can be obtained with white chalk on black paper. Try it as an exercise; it will teach you a great deal about gauging the balance of light and dark.

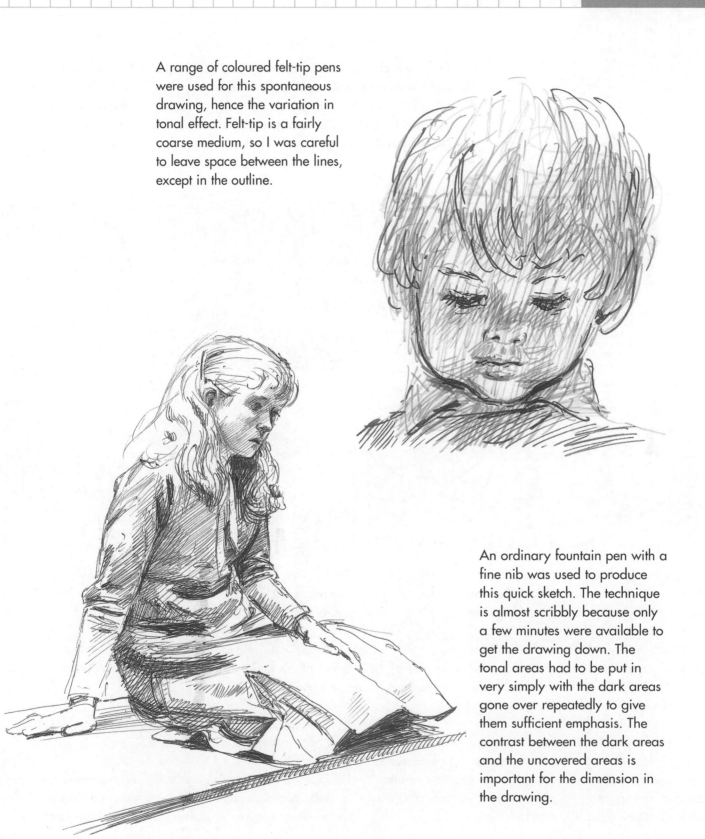

A range of coloured felt-tip pens were used for this spontaneous drawing, hence the variation in tonal effect. Felt-tip is a fairly coarse medium, so I was careful to leave space between the lines, except in the outline.

An ordinary fountain pen with a fine nib was used to produce this quick sketch. The technique is almost scribbly because only a few minutes were available to get the drawing down. The tonal areas had to be put in very simply with the dark areas gone over repeatedly to give them sufficient emphasis. The contrast between the dark areas and the uncovered areas is important for the dimension in the drawing.

DESIGNING A FRAME

Once you have chosen a subject to draw, the next step is to look at composition. The most basic compositional consideration is how you arrange the figure in the frame of the picture. The pose or attitude you choose will have a large bearing on this. Each of the arrangements shown here conveys an idea or mood associated with the subject. Good composition is never accidental.

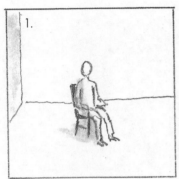

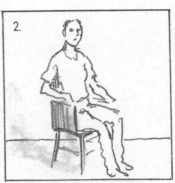

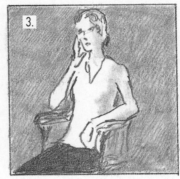

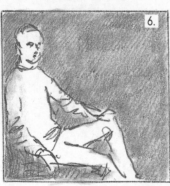

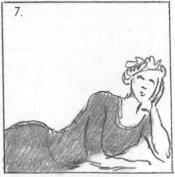

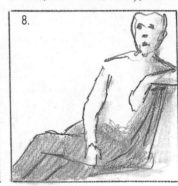

1. In order for this sitter to be clearly recognizable the picture would have to be huge. There would be a reason for choosing this degree of detachment from the viewer.

2–5. In this series of viewpoints the onlooker gets a progressively closer picture of the sitter. A tight close-up of the head demands that the artist achieves an accurate likeness, both physically and in terms of psychological insight.

6–8. An off-centre position can produce a dramatic effect. The picture becomes more than just a recording of someone's likeness, and we begin to consider it as an aesthetic, artistic experience. The space in the picture acts as a balance to the dynamic qualities of the figure or face.

9. Not many faces can stand such a large, detailed close-up and not many people would be comfortable with this approach. However, it is extremely dramatic.

10. In this unusual and interesting arrangement, enough is shown of this figure turning away from the viewer for him to be recognizable.

11. Showing a half figure to one side of the picture with a dark background adds mystery to a portrait.

12. Firmly placed centre stage in an uncompromising pose, this sitter comes across as very confrontational. The well-lit surroundings ensure that nothing is left to the imagination,

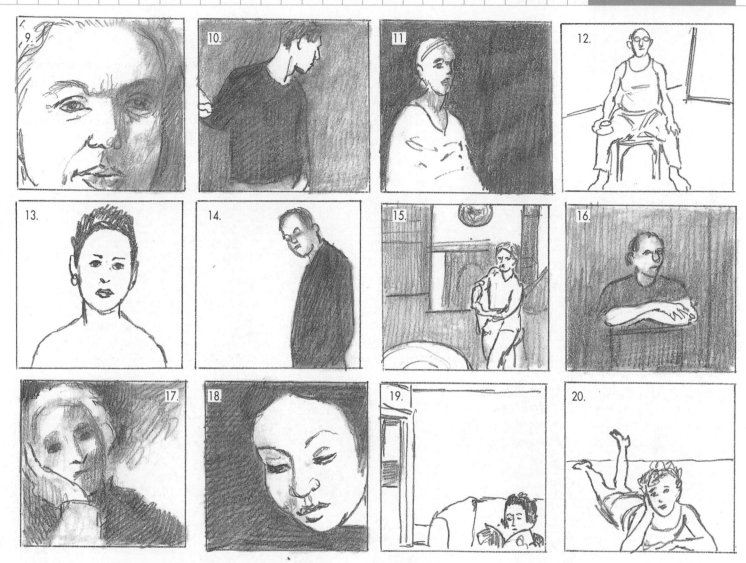

accentuating the no-nonsense direct view of the subject.

13. This head and shoulders view is evenly lit with little or no tonal values and absolutely no decorative effects. As such it demands a very attractive face.

14. The rather indirect positioning of the figure suggests a diffident character, and an almost reluctant sitter.

15. The figure takes up only one quarter of the frame. The emphasis here is on lifestyle and the ambience of home.

16. This sitter is made mysterious and moody by the device of posing him so that he is not looking at the viewer.

17. A soft, slightly out of focus effect can be very flattering, and in this example gives a sympathetic close-up of an elderly woman.

18. This close-up of a face floating in a dark void gives a dream-like effect.

19. An off-beat dramatic twist has been brought to this portrait by placing the sitter at the bottom of the picture, as though she is about to sink from our view.

20. This sitter is presented as playful, almost coquettish, by placing her in dramatic perspective along the lower half of the picture.

COMPOSITION

Here we look at examples of composition from two undoubted contemporary masters of portraiture, David Hockney and Lucian Freud. While Hockney has chosen to borrow from past conventions, Freud has more obviously struck out on his own. Both approaches make us either question the situation or provoke our curiosity, either of which is a good response to any portrait.

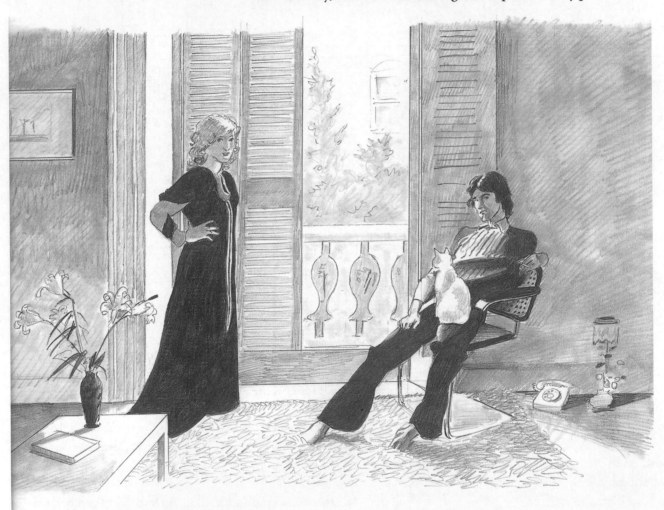

David Hockney's ability to echo the fashionable colour schemes of modern life in his work made him an obvious choice as portraitist of a fashion designer. In this copy, Ossie Clarke, his wife Celia Birtwell and their cat, Percy, are shown at home in their flat. The positioning of the figures is formal, almost classical, accentuated by the very dark dress worn by Celia and the dark legs of Clarke himself with Percy, outstanding in white, making three. There is minimal furniture, which might be as it was or because the artist arranged it that way. The position of both flowers and the cat is interesting in relation to the main subjects. The shadowed walls adjacent to the bright slot of the window give both space and a dramatic tonality which contrasts well with the two figures.

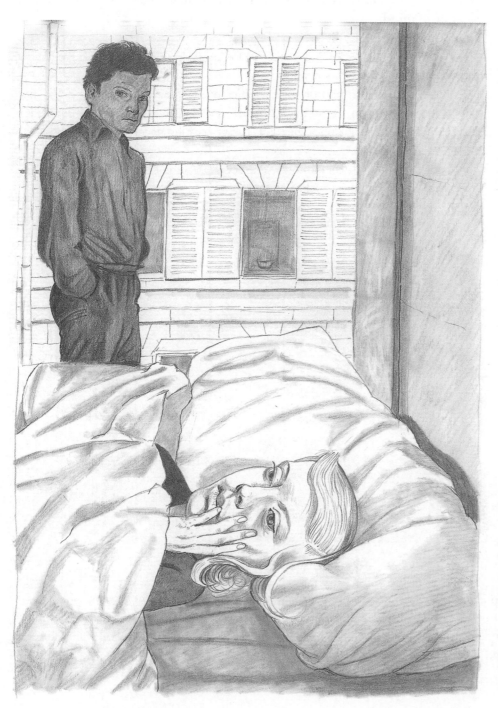

In Lucian Freud's double portrait of himself and his wife in a Parisian hotel bedroom the poses are as informal as the situation is ambiguous. Why is she in bed and he standing by the window? Obviously he needed to be upright in order to produce the portrait but he hasn't shown us that he is the artist. There is no camera, sketch book or easel and brushes in his hands. So what could be his intention? In the hands of a first-class artist this unusual approach has become a ground-breaking idea. The slightly accidental look of the composition is very much of the period in which it was painted (the 1950s).

HANDY HINT

Don't expect your own subjects to hold the pose for long periods, especially when children are involved. You won't be in the same position as the great Roman painter of groups of figures, Caravaggio, who, at the height of his fame, paid his models so well that they'd sit, stand and pose for him for days on end.

POSING

When arranging your subject, notice should be taken of the hands, arms and legs because they will make quite a significant impression on the overall composition. Portrait artists have always been interested in the relationship of the limbs because it can make a definite statement about a sitter's character or state of mind.

This example of a pose for a portrait has the advantage of including a typical resting attitude that the model might take.

All this is good in a portrait because it gives some movement to the pose, and allows the hands to be shown as well which is often a sort of structural bonus. It is easy to get portraits looking rather stiff, because of the necessity of the model to sit for a length of time.

A pose which brings in the arms and hands in some attractive way is a great help in giving depth and structure to the portrait.

In this copy of a Manet, a young woman is sitting draped around her plum dessert, a cigarette in her left hand while her right hand supports her cheek. The naturalistic pose gives a gentle, relaxed air to the portrait.

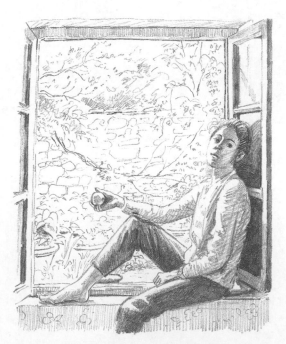

In this seemingly very relaxed portrait the frame of the window is also the frame of the portrait. The angles of the limbs make for a very interesting composition within this frame. It is not an easy pose to hold for any length of time, and so quick sketches and photographs were needed as reference for the final portrait.

Joshua Reynolds' painting of the dashing Duchess of Devonshire with her little son was in its time a ground-breaking picture. The hands and arms held up in delight by the child in response to the mother's playful gesture was a remarkable novelty in portraiture. The naturalness of this interaction stops this being just another fashionable portrait and turns it into a study of the interplay that occurs between any mother and child.

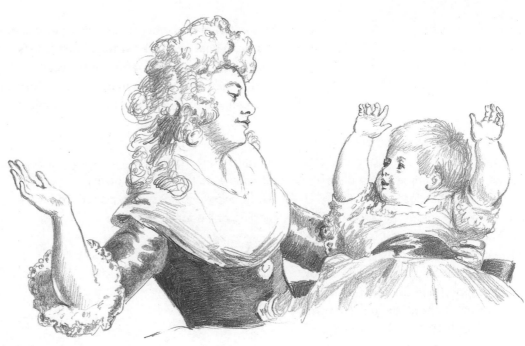

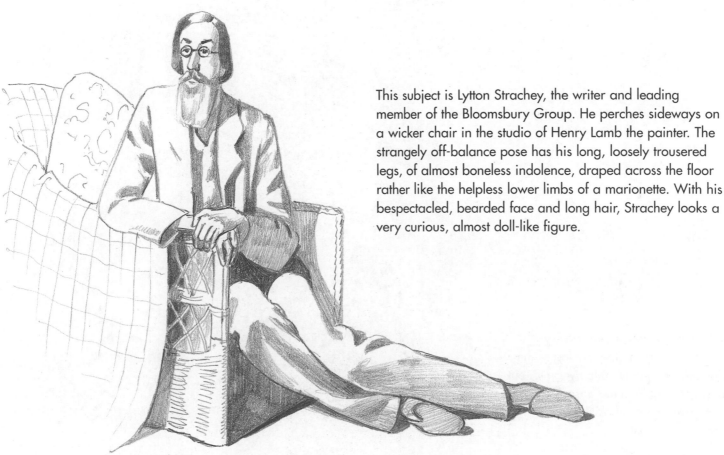

This subject is Lytton Strachey, the writer and leading member of the Bloomsbury Group. He perches sideways on a wicker chair in the studio of Henry Lamb the painter. The strangely off-balance pose has his long, loosely trousered legs, of almost boneless indolence, draped across the floor rather like the helpless lower limbs of a marionette. With his bespectacled, bearded face and long hair, Strachey looks a very curious, almost doll-like figure.

GROUPING FIGURES

All sorts of arrangements can make good compositions, and in the process tell us a great deal about the sitters. Most artists are interested in incorporating subtle hints about the nature of the relationships between the subjects in the groups they portray. You may choose to introduce an object into your arrangement as a device to link your subjects.

There are many ways of making a group cohere in the mind and eye of the viewer. In this example again after Lucian Freud, the closeness of the arrangement is integral to the final result. The central interest is shared between the baby and his parents. Our eye travels from the infant to the couple as they support him and each other on the armchair. In front, the elder son is slightly detached but still part of the group. The connection between the parents and the baby is beautifully caught, and the older boy's forward movement, as though he is getting ready to leave the nest, is a perceptive reading of the family dynamic.

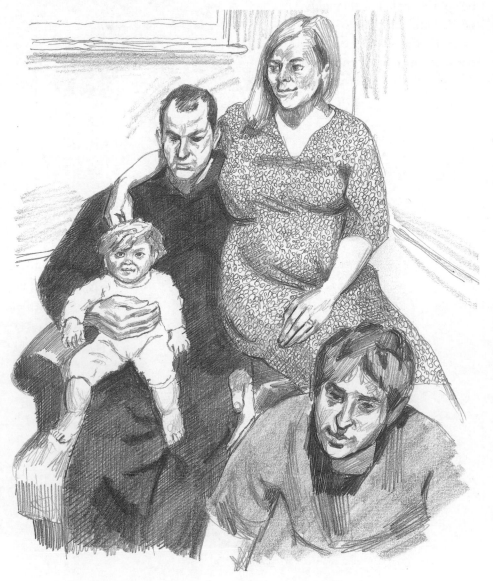

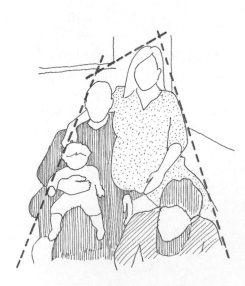

This arrangement makes a very obvious wedge shape leaning to the right. The shape is quite dynamic, but also very stable at the base. The slight lean gives the composition a more spontaneous feel.

This example might almost be a portrait of the car as much as it is of the family. It is the centre-piece of the arrangement, if not quite the head of the household. The pride of possession is very evident among the males. The females inside the car are less obvious, although the mother is in the driving seat. This sort of casually posed arrangement is more often found in photo-portraiture.

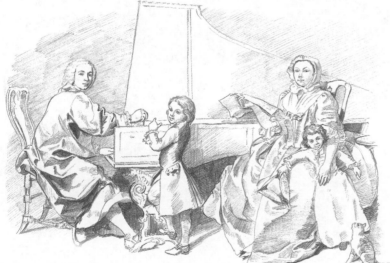

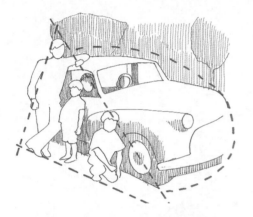

This composition is unusual and dynamic, partly due to the position of the car. The three figures outside the car form an acute-angled triangle which also gives perspective. The bulge of the car against the longer side of the triangle produces a stabilizing element.

HANDY HINT

The two adult figures and the lifted top of the piano give a stable effect. The curved line that links the position of the heads pulls the eye smoothly across the composition.

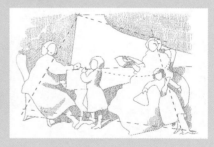

Like many 18th-century portraits, this is carefully posed to include clues to the sitters' social position. The artist, Carl Marcus Tuscher, wants to show us that these people are comfortably off – note the care that has gone into the clothing.

The head of the family is Burkat Shudi, a well known harpsichord manufacturer and friend of the composer Handel. The harpsichord is centrally positioned but set behind. If we were not sure that the family owes its good fortune to the

instrument, Tuscher underlines the connection by posing Shudi at the keyboard. The arrangement is balanced but relaxed.

BREAKING WITH CONVENTION

Most of the arrangements we have looked at so far have been formal in terms of their composition and very obviously posed. The approach taken in this next example is remarkable. The English painter William Hogarth was notable for his progressive social attitudes, and these are very much to the fore in this powerful and humane piece of work, in which he presents his servants.

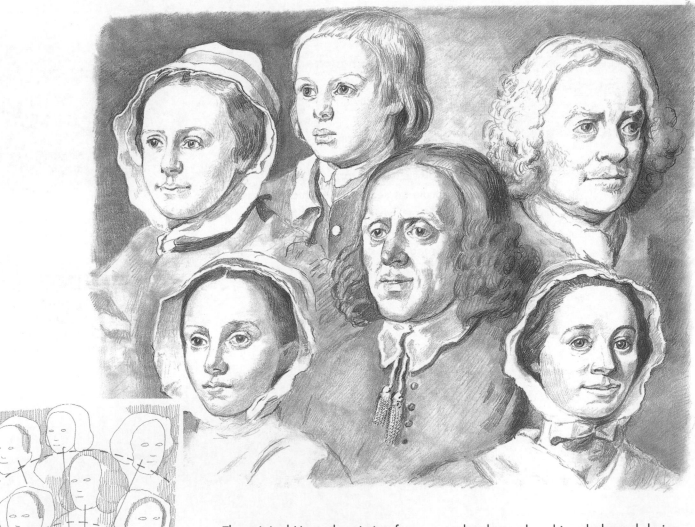

A very straightforward fanning out of the six heads from the base, placed in close proximity – all slightly off-centre but still very symmetrical.

The original Hogarth painting from which this copy was made is an extraordinary essay in characterization, executed with great brilliance, warmth and sincerity. The composition is exemplary. Each head, although obviously drawn separately, has been placed in a balanced design in which each face has its own emphasis. Hogarth's interest in his subjects is evident from the lively expressions; we feel we are getting genuine insights from a man who knew these people well.

OBVIOUS DOUBLES

Usually an artist does not get round to drawing a double unless someone specifically asks for it. Very often parents with two children will choose to have their offspring painted or drawn in this way, and it is a favourite method of married couples celebrating important anniversaries.

The close-up faces of these brothers gives an effect of family unity which we rather expect of twins. This degree of close-up is not an easy choice for the artist, however. The skin of children of this age (eight years) is smooth and the bone structure largely hidden by the flesh so that there are no lines of stress or tension to help give an accurate rendering. In such circumstances you have to measure out the face – and quickly, because the average eight-

year-old will not sit still for very long, and their faces are also very mobile.

This drawing was made from an excellent photograph by Jane Chilvers which won a photographic portrait award and now hangs in the National Portrait Gallery in London. I didn't attempt to put in too much surface detail because the smoothness of the facial surface is part of the charm.

Two round shapes, seen so close up, make a strong composition.

The pose in this father-and-son portrait – taken from a photograph by John Nassari – suggests a sense of humour in the artist and a sort of family complicity about the portrait. Despite the humour, the effect is fairly cool and detached. The uniform clothing gives the pair an oddly dressed up quality. The drawing is simple and mainly concerned with the outline, demonstrating that if you get the main shape right, individual qualities can shine through.

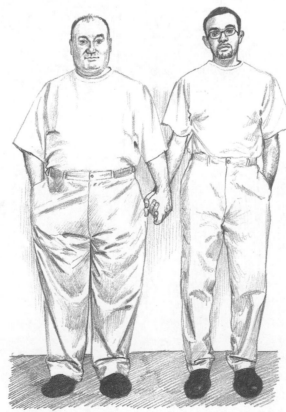

The two vertical ellipses overlapping in the centre make this a stable and uncomplicated arrangement.

SELF-PORTRAITS

Artists are their own easiest models, being always around and having no problem about sitting as long as they like. Some artists, such as Rembrandt, have recorded their own faces right up until almost the point of death. Drawing yourself is one of the best ways of training your eye and extending your expertise, because you can be totally honest and experiment in ways that would not be open to you with most other people.

Posing for Yourself

The most difficult aspect of self-portraiture is being able to look at yourself in a mirror and still be able to draw and look at your drawing frequently. What usually happens is that your head gradually moves out of position, unless you have some way of making sure it always comes back to the same point. The easiest way to do this is to make a mark on the mirror, just a dot with felt-tip pen, with which you can align your head each time you look up.

You can only show yourself in one mirror in a few positions because of the need to keep looking at your reflection. Inevitably, the position of the head is limited to full-face or three-quarters so you can still see yourself in the mirror without too much strain. Some artists have tried looking upwards or downwards at their mirrored face but these approaches are fairly rare.

If you want to see yourself more objectively you will have to use two mirrors, one reflecting the image from the other. This way you can get a complete profile view of yourself. This method is worth trying because it enables us to see ourselves the right way round instead of left to right as in a single mirror.

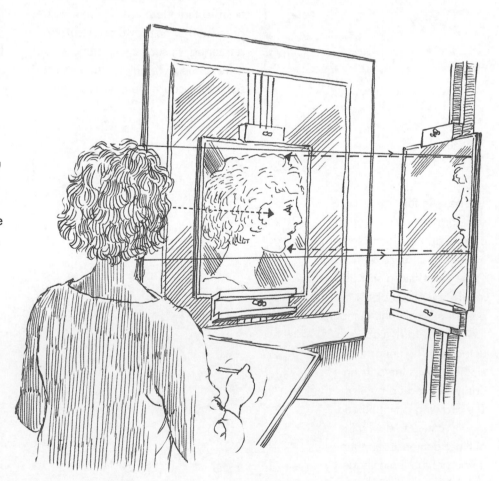

Individual Viewpoints

These portraits represent two different stages of Stanley Spencer's career, but despite the distance of 46 years between them both demonstrate the artist's honesty and his lively interest in the visual world he was recording. The younger Spencer is portrayed as a more expectant and confident individual. The second drawing was done in the year of his death and reflects a clear sense of mortality.

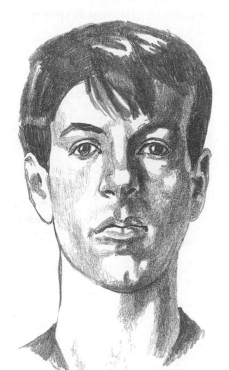

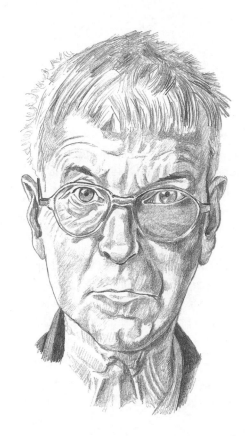

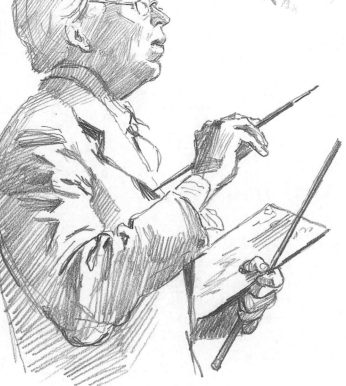

One of the most famous of 20th-century British figurative artists, John Ward has chosen to portray himself in profile for this self-portrait (1983). He has found a brilliant way of conveying vivid animation and a business-like approach through the pose (the balance of the poised brush and palette, the half-glasses perched on the nose, like Chardin) and the dress (formal jacket and tie).

CARICATURES

Caricature is an extreme form of portraiture. The essence of caricature is exaggeration. You have to take whatever you are drawing beyond the bounds of reality to an area of extravagant shapes.

The Process of Caricature

Every attempt at caricature begins with detailed study of the subject's facial features and an assessment of the relationships between them. Your observations will provide clues as to which parts you should exaggerate and which you should play down.

In this first exercise we are going to take a subject and put the features together in such a way that we end up with a reasonable result. Look at the sample face (right) – what do you see? When you have assessed his features, look at my stage drawings below.

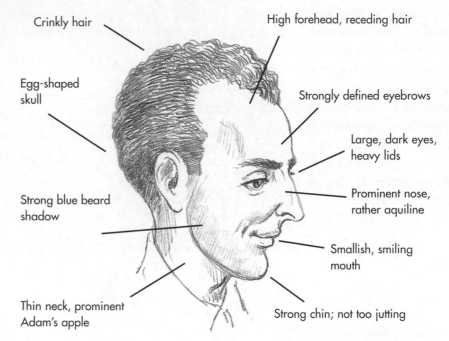

Crinkly hair

Egg-shaped skull

Strong blue beard shadow

Thin neck, prominent Adam's apple

High forehead, receding hair

Strongly defined eyebrows

Large, dark eyes, heavy lids

Prominent nose, rather aquiline

Smallish, smiling mouth

Strong chin; not too jutting

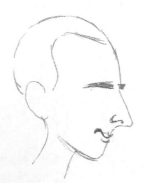
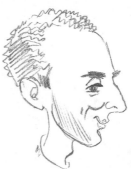
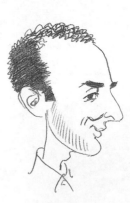

An egg-shaped skull attached to a rather thin neck. Draw this shape first.

Look at the way the hairline recedes from the forehead. Work this in.

Draw in the eyebrows strongly in thick black lines. Put in the prominent nose, making it larger than it is in reality. Give it a smooth, aquiline curve.

Place the ears well back. Don't make them too small. Add a dimple to increase the smile. Put tone on the jaw to suggest beard shadow.

Darken the hair. Define the chin.

Experimenting

Here are examples for you to experiment with and see how far you can take the exaggeration before the subject becomes unrecognizable. Try to capture the obvious features first and then the general effect of the head or face.

Don't try caricaturing your friends, unless you don't mind losing them or they agree. If you can't get the subject you want to pose for you, try to obtain good photographs of them. These won't provide quite such good reference, but as long as you draw on your knowledge of the person as well, they should be adequate.

These two portraits of British artist Tracey Emin are in different styles, but both capture her amused, provocative expression.

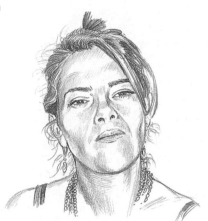

IDENTIFYING FEATURES:
1. Round head
2. Fat chin
3. Grim mouth
4. Heavy, anxious eyebrows
5. Little eyes with bags
6. Blobby or broken nose
7. Wrinkles and unshaven chin

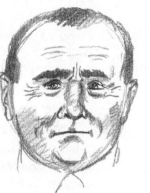
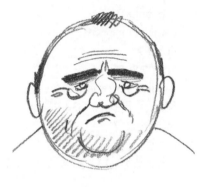

Normal Exaggerated

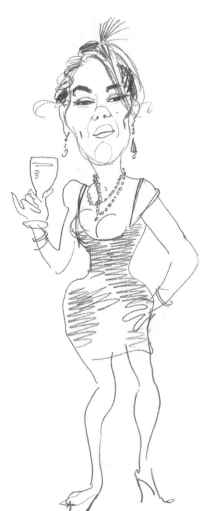

IDENTIFYING FEATURES:
1. Round-ended, turned-up nose
2. Bright eye
3. Thick eyebrows
4. Big hair on top
5. Chin
6. Cheeky grin

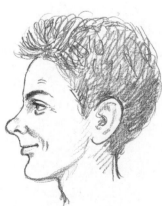
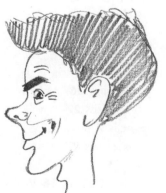

Normal Exaggerated

INDEX